# HOLY MAGIC

## Also by Priscilla Long

*The Writer's Portable Mentor: A Guide to Art, Craft, and the Writing Life* (2nd Edition)

*Fire and Stone: Where Do We Come From? What Are We? Where Are We Going?*

*Minding the Muse: A Handbook for Painters, Composers, Writers, and Other Creators*

*Crossing Over: Poems*

*Where the Sun Never Shines: A History of America's Bloody Coal Industry*

*The New Left: A Collection of Essays* (Editor)

# HOLY MAGIC

## Poems

# Priscilla Long

MoonPath Press
Albiso Award Series

Poetry
ISBN 978-1-936657-56-8

Cover art: Poetry Stage, Equinox, December 12, 2015, Photo by M. Anne Sweet

Author photo by Jerry Jaz

Book design by Tonya Namura using Baloo (display) and Gentium Basic (text)

MoonPath Press is dedicated to publishing the finest poets living in the U.S. Pacific Northwest.

MoonPath Press
PO Box 445
Tillamook, OR 97141

MoonPathPress@gmail.com

http://MoonPathPress.com

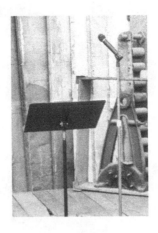

Dedicated to

Jane Schlosberg, Sandra Nickerson

and

Janiese Loeken

and to

the memory of
Susanne Long (1946–1986)

*Let wise men piece the world together with wisdom*
*Or poets with holy magic*
*Hey-di-ho.*

—Wallace Stevens

*It is not news to anyone that color carries meaning.*

—Kay WalkingStick

*Rage for the world as it is*
*but for what it may be*
*more love now than last year.*

—Muriel Rukeyser

*Can you express through color*
*your feelings about science and of life?*

—Wassily Kandinsky

# Table of Contents

# HOLY MAGIC

# THE RED PEAR

*Color is troubled light.*
—Goethe

## Art & Life

Art saves nothing
and this is not art
just words running
in lines, hoping to reach
redemption. Meanwhile
time is running          out

for bat and bobwhite,
damselfly and butterfly.
Coral reefs are dying
and salmon, once wild,
breed in tubs. Don't put
your hopes in poems

that plot the putrid doings
of bankers, that bank
on Franz Marc's *Red Horses*
gamboling and grazing,
as if we'd never learned
to fabricate glue from hooves.

But look. The peregrines
are back, startling starlings
into masterpiece murmurations.

## Consider the Red Pear

*So what good are your scribblings?*
        —H.D.

Beauty. The red pear
Cézanne painted among jade
and wood. Or Miró's orange
sun rising in *Red Sun*. Or H.D.'s
charred apple tree blooming
in the bombed ruin of London.
The poet's pale petals drift
down our long years. Art endures.
*The stylus, the palette,*
*the pen, the quill endure.*
In my backyard, a stone
Buddha laughs.

## Burnt Offering

*Arshile Gorky (1902?–1948)*

1. Charred Beloved

Cadmium red, fire-charred
dark: a barnful of paintings
burnt to umber, to black.
Not your first singed brush
with death. Yellow ocher
licks the moon. This night's
burning: all your years.

2. Suicide Note

Paint twisted red.
The broken lines
of *Agony* thicken to blood.
Was this your mother's
hunger-doom, the charred remains
of love? In *Last Painting*
the fiery dark burns
too hot.

3. Your Mother's Embroidered Apron

Buttercups. Green
sunspots on stone floors,
jugs of cream, shadowfolds
of arms. Simple loaves.
Before the firestorm:
the yellow light
of Old Armenia.

## Facing East

*If you look the light of the world*
*in the eyes, creation turns scarlet.*
          —Derek Jarman

I write fire, sun,
desire, all that burns
white hot on the page.
My window frames
frozen grass, frigid rooftops.
My street refuses to snow.

Wind chimes the hour.
I wish it were so. Easier to sip
tea in slippers than to face
east, to where the cold sun
flings its fine fire. We dream
cobalt and copper dawns
too terrible to take with toast,

so, peer at mirror-pores,
stare down frown-fraught eyes.

## Writer's Circle, Raelene's Turn

You speak of your writings
shoved into shoeboxes,
your face blank as a page.
You read us titles—poems
indexing your years: poetry
as biography, biography
as geography, red-earth
memories of Mexico. You
tell us William has died,
a painter you once loved.
You read from an old journal,
how history inscribes the land—
stone markers, Indian arrows,
the landscape a creased face.
Then your face breaks
into grief, not for the earth,
not for William—but
for all the lost poems.

## Things That Are Red

*It is the color of fire and flame.*
        —Alexander Theroux

October, its flame-
colored filbert foliage
forgoing green. Red
manure worms eating
and mating in the wormbox.
Fuschia petals tantalizing
hummingbirds, tempting bees.
The sun red and low
in the west, Earth ocean-
tinted silver-gray, rose.

Trayvon Martin's blood
was red, his hoodie black.
He was on the phone,
walking home, his skin
was black. In Sanford
he was chased down,
shot down. He was 17.
His killer, America,
calls Black Americans
"slime." His killer—
America's shame,
America's crime.

## Words Referring to Unspeakable Events

*Love, like the heart, is red.*
            —Derek Jarman

This dawn of smoke and flame—
the tiny bones
of tender feet
turned to ash—
let us return to chants and songs,
to our first loves.
This murderous dawn—
let us return to birdnest,
storybook, pillowtalk.
Let us speak to one another
from our heart. Let us hold
the bereft in the temple
of our soul, and fill our soul
to overflowing
with their emptiness.
Let us speak in poems
that smoke and flame.
Let us speak to the dead
who walk among us.

## Hermit's Chronicle

*I see by my own light.*
                —Sylvia Plath

At first light, a thicket
of mountain ash clots
the windowpane. I put
right pots, jugs. I sweep
the hut, polish the Red
Stone. I run the dog,
shovel coal ten hours.
Home, I fire a log, read
the misanthrope—Larkin.
Nietzsche wags his tail.
I light a black candle,
slip into dreamsmoke
old as wooden clocks,
or cogs of waterwheels,
or burning wax, or sex.

# ARCHAEOLOGY OF ORANGE

*Elvis, by the way, loved orange silk pajamas.*

—Alexander Theroux

## Ghazal in Orange

This dream, your face turns orange.
Your red hair burns orange.

Matisse floats in liquid blue lucidity.
His *Red Studio* yearns for orange.

Bombs flame red. A prewar photo,
all dolls and smiles, turns orange.

Purple desires blue. Blue wants black
and blue. Dragon's Blood spurns orange.

I'm a Red. I'm a red-faced girl in October
long ago, watching elms learn orange.

## Eve

Adam, Father lied.
That twisting fruited tree
can't make you die.
Nor can turquoise leaves,

trumpet-flowering vine,
or burnt-orange dream disguise
the loveliness of naked truth,
my godforsaken mind.

## Matisse's Radiance

*Love is a great thing, a great goodness.*
    —Henri Matisse

London in flames, corpse-
smoke in the street, 1942.
Matisse in Paris paints
*Dancer in Blue Tutu,*
retreats to retinal red
fish, his blue bathers
blind to war.

The world in war
yearns toward evening
light. Somewhere
someone pours tea.

Later, wheelchair-bound,
the painter wields scissors
to make orange suns, blue
ivy, tender purple jazz.

## Pterosaur Pantoum

Winged dragon of the Mesozoic
you pterosaurs, were you orange?
You perished before the Cenozoic.
Giraffe-big, high-flying, strange.

Pterosaurs, they say, were orange.
Reptilian being of hollow bone,
giraffe-big, high-flying, strange,
the great wings a membrane.

Reptilian being of hollow bone,
air-sack buoyed, beauty-bright crest,
your great wings a membrane.
Dream of orange flight now lost.

Air-sack buoyed, beauty-bright crest,
your big brain and long beak.
Dream of orange flight now lost
to bird and bug, to white jet streak.

## Ode to Fire

Fire is cookery, crockery,
Celtic cauldrons worked
in iron or gold—smoke
of sacrificial fat.

The Great Fires—Chicago,
Seattle, San Fran—blazed
through wood. Cities
rebuilt in steel and stone.

The bomb-kindled fires
lit funeral pyres:
Dresden, London,
Nagasaki—apocalypse.

Coalfires keep
the hearth, simmer the stock.
The kettle steams, but Earth—
the earth burns.

## Acknowledgments

I am born of darkness.
I acknowledge the dark.
I am the garden Buddha cut from stone.
I acknowledge the ancient mountain.
I am a flower, orange and solitary,
    blooming in the swamp.

My will is tempered steel.
I gratefully acknowledge
    adversity's fires.

## Tarot Spread: Divination

*Let us substitute*
*enchantment for sentiment...*
                —H.D.

I'm blindfolded, blind
to a past I cannot see.
I stoop—fieldhand,

peasant bearing stones,
rootwads, stumps.
But wishing to fly,

wishing to sing, wishing
to sink into oceans
strange with sea-urchins

or that unctuous orange
octopus. Wishing to swim,
I'm let to swim,

guided into the deeps,
lifted by some fishy muse
into lightness and light.

# GRAPE-COLORED FIGURED SILK

*Splendid things: Grape-colored figured silk.*
*Violet is a splendid color wherever it is found—*
*in flowers, in fabric or in paper.*

—Sei Shonagon

## What Can Happen

*Meret Oppenheim*

Indigo jazz stains
the visionary night.
Kisses rot under logs.
Lost purple thrills
perfume purloined shadows,
fur-covered teacups.
Meret, your *vowels* keep on
*voiding.* A sax sweet-talks
the moon into shedding
her black bats.

## Indigo & Violet

Indigo's deep, black before dawn.
Violet's an evening song.
Indigo's ex is silver,
Violet's—obsidian.
Indigo is bluish-black, glowing.
Violet is pale, *grape-colored*
*figured silk.* Indigo's the color
of night, lapis, lost love.
Violet is frothy, scarves
and jewels, glints of sealight.
Indigo's indigenous, indignant.
Violet floats and flirts.
Indigo plays cello
adagio. Violet, the viola.
And so it goes, *the dance*
*at the heart of being.*

## Things That Are Purple

Bruises. Irises. Mountains
distant. Iridescent crows.
Purple jasper, purple jade,
lilac blooms. Plums,
evening shadows. Purple
petunias. The primrose.
Prince singing *Purple Rain*.
To Kandinsky, violet was sad,
a cooled red. So, a mood
can be purple. Me? I say bliss
is orange, sorrow, indigo.

## Poet's House

*The power to make.*
            —Muriel Rukeyser

1.
Logs spit guttural sparks
on a pink-tiled hearth.
Paintings dream ethereal
umbers, rude ochers.
Among russet-soft chairs,
rugs, and books, two cats
sleep, preserving the ancient
Egyptian cat. The mantlepiece
cannot forget its tree.

2.
Pleasures and dangers tangle
in sheets. In mauve-colored
dream, donkeys refuse
to budge. But symbols
turn up-side-down or float
above the soup.
In the sleeping room resides
the spirit—
at once male
and female, always dissolving,
without substance or declaration
like color, image, idea.
She won't be bossed.
On a bad day she disappears
into someone else's dream.

3.
The study is sacred to the ego,
the body to its bath and pot.
The ego is a fussy thing:
it must have praise
pinned on every wall, accolades,
accomplishments, all blame
filed deep in the perfect desk.
The study must have its pencil jar, just so,
pencils sharpened, words,
first a bucket of peduncles
but they don't suit, then pot and lopper,
rake and rock. I take the rock.

## Beauty of Coal

Color of coal: sulfur-tinted
to copper or peacock. Oil

slick green-maroon. Paleozoic
black, or else brown coal,

lignite, ancient frond visible.
Shape of coal: stone, or strange,

a snake coiled to stone.
For coal was once a snaky bog

sunk beneath shallow seas,
and before: tree ferns, haze,

horsetails, warm rain,
green dragonflies in sun.

## Abstraction

*Mark Rothko*

Grotto of sleep, dark,
not black but soft,
deepening to violet
below dream, to underwater
cave, imageless, edgeless,
the dream of not
dreaming, floating
in corporeal darkness,
down below down, a weightless
weight, the self dissolved
in a sea-change, strange
caverns gathering night.

## Old Fathers

*I have no child, I have nothing but a book;*
*nothing but that to prove your blood and mine.*
        —William Butler Yeats

Oak trees darken to mauve.
Autumn disturbs my sleep.
*Pardon grandfathers, old fathers*
my vision: the solitary mountain,
yellow birches fluttered by storms.
I have no child to prove your blood.

I wrote a book to prove your blood.
I sleep in silk, dream in mauve.
A girl, I thrilled to thunderstorms.
Wild geese seared my sleep.
My vision: a monk, a mountain.
What were your dreams, old fathers?

*Pardon, grandfathers, old fathers.*
But what of your wars? The blood
of children? On the mountain
my mind's monk sits in mauve
air and bids the children sleep
through bombs and firestorms.

Poets thrill to thunderstorms.
Oh, Keats and Yeats, grandfathers,
we lovers kissed in our sleep,
ignorant of birth or blood.
We wrote purple poems, wore mauve
and damask silk, danced the mountain

top. Eternal the mountain,
its mist and crag, its storms,
its skirts and skies of mauve.
We carry the blood of our fathers.
We turn in *their* sleep.
Our poems will prove their blood.

Or will not prove their blood.

## Tasks of Solitude

*I am working out the vocabulary of my silence.*
      —Muriel Rukeyser

To learn the dawn-purpled dark,
winter's ruby light rinsing
rugs and books. To hone obedience
to cats: cat-blinks, cat-lappings.
To keen the silvery moon
hung on a dark throat.

To unlock the door:
to enter the room of blue jugs.
To pour darkness from the coffeepot,
to learn the edges of darkness:
doorjamb, floorboard, candleflame,
the wavering edge where desire
thickens and vanishes like smoke.

# A GLASS OF
# BITTER ALE

*My sister, the sun,*
*broods in her yellow room and won't come out.*

—Derek Walcott

## Things That Are Yellow

Butter. Buttermilk.
Cake batter. Corn-on-the-cob.
Popcorn. Corn chowder. Moon-

light, Van Morrison's
"Moondance." A van Gogh
poster scotch-taped to

a yellow wall—that
memory. Urine's yellow.
Raincoats in black rain.

Lions. Dandelions.
A glass of bitter ale. Dark
ocher oak leaves. Birch

leaves. Yellow peas. My
face, blue-black yellow
bruises—that memory.

## Late Afternoon Nap, Thinking of Susanne

August drips its melon light,
spirals down the hourglass.
Summer whispers through me once again.
Thick as sisters, the redbud,
the dogwood. Thick the laurel leaves.
I spin a spiderweb to sleep,
briefly touch your cornsilk hair,
your sun-bronzed, summer face.
You now, ten years dead,
ash and bone in the grave.

## Lantern

*Let us have a good fire and be beloved.*
        —Rig Veda

Reading in the kitchen;
yellow potatoes boil.
The pages are yellow, an old
story in an old storybook:
a gnome, a pigtail girl
talking to her teddy bear.
It is night. The moon
is yellow. A wood stove
burns a birch log, bakes
biscuits. In this yellow
light, being is well-being
and all is well.

## The Journal of Eugene Delacroix

I turn the pages of his book,
its notes two centuries old:
kisses, yes, and how to look

at light, how to work
Naples yellow into tones of gold.
I turn the pages of his book

quick to mock
mediocrity, to speak untold
caresses, yes, and how to look

at *shiny coats of bays and blacks*
and brook an idiot in the Ingres mold.
I turn the pages of his book

so full of friends, and music: Gluck's
overture. Chopin, George Sand, their bold
kisses, yes, and how to look

at Rubens, and how the painter took
sick, stomachache, head cold.
I turn the pages of his book
recounting kisses, yes, and how to look.

## The Yellowwood Wood

*After Allen Grossman*

The poet spells yellow:
a yellowwood wood, a yellow-
wood bench to loaf upon. My poem
purloins his lines: *leonine death-
gold of Autumn.* Of the great cats,
only cheetahs purr. In this yellow-
wood wood, truth dallies,
deliquescent. Luteus leaves
twirl down like birds. Death
will get its winter day.
Our yellowed pages stay.
Let the world go dun
and orange, or rot
in blots of blue, or burn.
I'll loiter here.

## Ars Poëtica

The common yellow of urine:
not used like moons in poems,
not overdone. Odiferous, odd,
despite its daily stream.

Despite Duchamp, urine's
uncommon in art. Yet why not
put urine in? Let it pour
from the body's urn, its color

of cardamom, saffron, lemon,
its ocher steam, its humble
animal origin. We look up
to logic, spirit, thought.

But urine's sterile and pure. Its
potassium, nitrogen, phosphorous
could fertilize our fields,
ground our airy poems.

## Nuclear Patchwork

The fiddles of Harlan
hung on planked walls
will moan to the wind. So
on sunless Appalachian porches
the rocking chairs will creak.

A gesture as simple
as one tender touch
will scatter
the four shape notes,

obliterate the ringing silence
after the old man fiddles
*Devil's Dream.*

The basket of yellow scraps
will sit there in the corner
for centuries.

# OLD JADE

*Far below, the Skagit River*
*winds toward the sea*
    *like a pattern in old jade.*

—Robert Sund

## Allison in Leaves

*Dozens of dialects of green...*
          —Tomas Tranströmer

In green memory, barefoot,
my niece perches parrotlike,
perfect, at home out on a limb
of a sycamore tree. Her pants
are green, her teeshirt, white
and green. The light is green.
She holds out for all to see—
a green pear? As leaves sparkle
yellow splats and dots, so Allison's
yellow hair is lit up, green.
This photo, awash in summer
proves that happiness is green.

## Metamorphosis

*Made to rhyme with the painting* Anamorphosis *by
Margaret Tomkins*

the river slips from ocher to umber
to rain-runneled rock, its mutations
mute, uprooting slow-spiraling
worlds roiling worms and vines
into forms unnamed as femur
or fern, root or vein, archaic
as kin, coming to words,
begin to tell in mother-tongue
moon from wine from stone
and the tale slow-tumbles
into memory's dark river and
the river slips from ocher to umber
to rain-runneled rock, its mutations
mute...

## Pisces

Our brain is brine,
memory a croak, a plop,
raindrop, swallow-swoop,
grandfather, Great Mother,
rivers running to salt.
I am the catfish
memory holds, eels
writhing phallic and free.
Love me sea-green and I'll
slip your water worlds
through finny pores and gills.
Never mind my fish-whiskers
wishing for river muck.
We fish flash in schools.

## Duwamish Waterway

*For the river, there is late November*
*only, and the color of a slow winter.*
        —Richard Hugo

Here runs the Green River down to the Duwamish
where sea lions deposit their big bodies on winter rocks,
where gantry cranes reach skyward—orange birds,
where harbor seals blink and wetly stare and dive,
where crane operators hoist box over box,
where America trades pig feed for plastic potties,
where Indian middens harbor shells and secrets,
where PCBs redden eyes and blacken crabs,
where Boeing builds 747s and Foss Tug tows barges,
where Richard Hugo made his name and poems.

## Green Air

*Chicxulub (CHICKS u lub): the asteroid
that collided with Earth 66 million years ago. The hit
and its effects wiped out 80 percent of life on earth,
including both non-avian dinosaurs and pterosaurs.*

Green air trembles dragonflies
amid horsetail and ginkgo
verdant beside warm seas.
The *T. rex* raises her immense
head. She's bone-crushed
her dinner, a tasty *triceratops*.

In the night sky—
a new pinpoint of light.
Does it come as a shudder,
the impact, as a faint shock,
or as nothing at all? Only,
in coming hours, a darkening
till fireballs drop from sunless skies,
forests burst into flame. After which
Earth turns to ice, soot, and ash.
Mute creatures hunger, their dying
in their eyes. Air chokes with fear.
The young *T. rex* lopes, stops,
starts. She cannot last.

The freeze ends with a blast of heat.
Air—nitrogen, oxygen—cooks
to nitrous oxide, deadly
acid rain. During the dying months
of cold and dark, small creatures
scurry, mouse-sized mammals.

On this hot August day
droning distant airplanes,
I honor the young *T. rex*.
I think of her muzzle dipping
to drink, her fangs, massive, fragile,
her catastrophe, our leave to be.

## Frozen in Memory Your Peacock Beauty

*After viewing*
Peacock, *1907 by Julius Scheurer*

Death set adrift your artifacts:
a Moroccan change purse,
red-leathered, finger-soft.
A beaded copper necklace
forgotten by your long neck.
The African burlwood bowl,
your lace-edged camisole.
Death disgraces, devours
indigo, ruby, green tourmaline,
and if a peacock painted in 1907
could see in his bird's-eye view
your death's detritus, he would
croak his long and terrible screech.

## Her Last Garden

Gertrude spades loam, intercedes
for orange clock vines, imagines jade.
Mild air and a worm herald winter's end
but the bare garden withholds
its maker's ode to spring.
Still, crab apple portends petals,
the stone wall—cascades of wild roses.
Remembering how buds yield
to the sun, Gertrude cuckolds time.

# BLUEBIRDS

*A blue stone is anything but
a blue stone. It is a speck of sky
in your hand or a tiny bit of sea.
Of all stones, it contains
the most magics.*

—Richard Hugo

## Blues Factory

*And so I fell in love with a color...*
     —Maggie Nelson

We blast indigo
out of dusk, dig
dark cobalt, smelt
the low notes, purge
the Reds. We eschew
sky-blue, extrude blue-
black, aggregate
cerulean, lapis, dark
navy. We stir, cook,
break, cut, stack, and pack
the blues into blues crates
labeled bluestone or blue
agate or American Blues,
Chicago style. Once
in a blue moon we
ship dark amethyst.
Yes, we get the blues.
We go blue with cold.
We get the factory-worker
blues, the lovesick blues,
the blue-moon-shining-over-me
blues. And yes, we play the blues,
we play the red-hot honky-tonk blues.

## True Blue

A blue tutu
and an old shoe
ever true, no longer
new, thrown together
till now the shoe is blue
and the tutu can taste
its tongue. Their house
is a cardboard carton.
Each was dumped long ago,
one by a girl, the other
by the other shoe.
Now they're an odd two,
a contented conjugation
of tutu, shoe, and blue.

## Bluebirds

*In Memoriam, twelve young African American women serially murdered, winter 1981, Boston.*

On Randolph Street a woman's body lies.
The sky is trapped in wires.
We're printers talking printing, and the news
inside a grimy factory gate.
The morning never ends.

Then Michael comes
with this design for us to print:
He wants a bolt of gauze now plain
to glint in green and gold,
to fairly burst with apple trees
and sounds of twittering.
We'll see what we can do.

So rolling out the cloth that Michael brought,
we let the bluebirds out.
Blue happiness is flying everywhere.
It came from her
now lying dead on Randolph Street,
who once threw back her comely head
and laughed.

## Nuclear Winter

After that war, still, the tides
will tauten and slacken
on the moon's rope.
The earth will turn, and turning,
snowpeaks mirror sunlight
in sharp blue mornings.

And there will be colors:
grey and white mist,
the old red sky at dusk,
the deadpan moon, and Earth
everywhere blackened.

And, foraging
on the ocean floor among cave
and cavern: enormous, eyeless
sea-monsters—the word
comes from our storybook mind—
prehistoric benthic
invertebrates that move
through human understanding
into the darkness beyond.

## Among Books

Burrowed in a carrel,
I remember your eyes
the color of stones.
I malinger among the poets—
from Whitman to Walcott—
excreting sorry blue lines.
Outside a winter gale rants.
In Europe war scatters
lives like bread to birds.
But the twisted rag my heart
is blind, deaf, and dumb
to all grief but its own.

## Otis Redding

Here tonight, daisies
glow in drifts like moons.
I'm home from nightschool,
sipping merlot, remembering
Otis—*sitting on the dock
of the bay*, that long-ago
trip to Tortola, Otis
already dead six years.
We camp on a sailboat
some guy lent us, anchored beyond
mosquitoes. We dream all night
steel-drums. I return alone
to Boston on the Greyhound
through Florida's odor
of denture paste, Georgia's
dirt roads and shacks. In Macon,
a layover and that hobo. His saga
winds through a long night,
how he lost his way-
faring buddy to a woman,
a lonely tale told to a stranger
in a bus station, forty years ago,
Otis rocking on the radio.

## Insomnia

*Blue is a mysterious color...*
        —Alexander Theroux

Night is a room, solid
wood and silence.
Books line the walls,
hoard words once worked
by Akhmatova, Komunyakaa.
A lone car passes. The house
breathes its brick and tile,
opens its shuttered eyes to stars,
to black trees, cold October
air. The rug plays patterns
like music—curling
and repeating burnt sienna,
cinnabar, deep midnight blue.

## Nisqually Delta

*For Susanne*

The wind is up, the sky cold
over the Nisqually mudflats.
Small trees poke through wave-
white froth, the flooding high tide.
Great blue herons stand motionless
as icons. Gulls sail blue air. Ducks
duck into white water.

I would show this delta to you
who are dead by your own hand
thirty years, but you cannot see
the wild sea nor hear croaks
of ducks nor your other sister
clumping joyfully along the long
boardwalk to McAllister Creek.
She marvels at dunlins flashing white.
Your toddler niece, now 33, points
to a bald eagle high on a branch—
a spirit messenger—so they say.

## Requiem for Rwanda

*And I come to a scene where nothing shines.*
            —Dante

In my garden it rains. Foxglove
flesh droops. A robin trills
his three-note song.
The newspaper hits
the door, insistent as crows.

I lay it open to corpses
clotting river weeds.
I sip strong coffee, see machete
metal slit eye and cheek,
the skull-bowl of dream.
A river rocks foot and fingerbone
once memorized by love.
A river swells
with breast and mother-tongue.
Farmers weep
to haul this hell-harvest home.

My finger tracks
a ragged blue line,
the ravenous Nile. It maps
my body's geography,
clavicle ridge, petal-soft neck.

A farmer lifts in rubber-gloves
a child's skull, her small foot.
He lifts a woman, her five children
bound, each to each, drowning stones.
They'd dressed that morning in red
and yellow. In bright blue.

## The Blue Distance

*The world is blue at its edges*
*and in its depths.*
                    —Rebecca Solnit

Mist, lifting waves, white
gulls wheeling in wet air,
the stone-salt sea, and pearl-
pink sky turn this day inward.

We walk the Wellfleet dunes,
the jagged rock jetty. Our talk
forms, drifts, reforms, unfolds
kaleidoscopic as memory
turning and tumbling
from a single mind: Picasso
in occupied France, the secret lives
of poets, one's twin, another's son,
questions of autobiography, stories
our grandmothers told.

We feast on smoked bluefish,
raw oysters, broiled red peppers,
basil green and salt air.
We talk novels, argue history,
laugh heartily over dessert
at the big bang theory.

Later the sun, lazy bright coin,
takes the day down. We fall silent
on porchboards. Evening gathers
into gust and breeze. In the blue
distance, waves break into light.

*For Howard and Roz Zinn. For Elly and David Rubin.*

## Alchemy of Kitchens

*After an image by Leonora Carrington*

Sunfires pierce the pane.
I shut my lizard eyes.

My cottage in her summer dress
flames peonies. There a wizard,

drunk, flung bottles into weeds.
Now spirea spits green glass.

I grow old as crocodile bones.
Sauce thickens, gauze tatters.

Here a white goose, fat
as a fridge, waddles in.

Blue gems in blue jars
wink at thinner worlds.

# NIGHT AND SUN

*At the edge of imagination there is a black sun.*

—Olivia Parker

## At the Museum Café

It's my fault, I am
bored with art. Geri, Anne,
Gordon, Jack: This poem
has no sight, nor insight.
I sip Viennese coffee.
I think of old Vienna, city
of opera, Wittgenstein,
Egon Schiele. I want
passion and fire, the deep blacks
and hot reds that art and love
require. Instead, I sip *this* black,
*this* hot, contemplate white bone
china, rim rhyming rim.
I tip brew to tongue, hand
to mouth. This calming cup
of nothing much is what
it is: beauty, strong and black.

## Night and Sun

*Love is, as you know, a harrowing event.*
            —Anne Carson

Night contains myriad suns,
galactic light, moondust
beams, shooting stars,
tides of darkness
dreaming eons gone.
Night contains
the moonscape lit
by earth: Moon's Seething
Bay; its Bay of Dew,
its Sea of Rain
and Lake of Dreams.
Though sun is blind
to night's black
glittering, night sighs
all night toward sun.

## Blind Man with Banjo

He recalled color:
green eyes, black coal,
the sun red before darkness
descended on his childhood.
His gut-strings vibrated
silver arpeggios, blue notes
sparkling motes of light.
And what a figure he cut, dazzling
a scene already luminous
with lesser lights.

Was it he who claimed it paid
to busk loud and dumb?
The scene scattered, but he stayed
on a Park Square bench.
I see him year after year,
my music teacher,
playing *Cripple Creek*
as if he were begging,
as if blindness had fallen on sound.

## His Daily Walk

*For Winslow Long*

I take my evening walk—rainy
streets, yards, and garden fences.
My walking stick's a daughter's gift,
for I refuse a cane. I name the plants:
bleeding heart, blue-eyed grass.
I make my way—then stop.
A pile of feathers, black,
a chick, the gape a hungry pink.
Above, in hemlock branches
two crows flap and yell, fly up and down,
distressed, their nestling nestless.

No way to help. I think of my lost
child. No spring can salve
the loss in thirty years gone by.

The evening's changed. The baby
bird's too weak to fly. I tell the crows
I mean no harm. I make my way

through May, through streets
that rain and rain. Whoever says
that man's above a common bird
has never lost a child.

## Black Diamonds

Coal bearer, bent, creeps toward the sun
beneath the dank and feudal British earth.
Blackened by new riches, she is wife to none.

Two men heave the precious burden on
the harnessed human beast, to paupers born.
Coal bearer, bent, creeps toward the sun.

A candle in her teeth, wax on her tongue,
she lights the damp for fifteen hours, by yards.
Blackened by new riches, she is wife to none.

Hewers, serfs to Lords, take wives to bear their tons.
The fremb brings up unmarried stranger's corf.
Coal bearer, bent, creeps toward the sun.

Alone with him by night (and night is never done),
she takes each unknown hewer's heartless load.
Blackened by new riches, she is wife to none.

Heat, rail, steel—civilization—
was brought to light on aching human backs.
Coal bearer, bent, creeps toward the sun,
blackened by new riches, wife to none.

Note: In the early (twelfth century) British coal industry, a
fremb was a coal bearer unattached to any miner's family.
She was assigned to a different hewer every day.

## CoalTime

The stone of coal
on my work table
compacts eons. It's bog,
fern, a form of rhyme,
life's common carbon.
I too am carboniferous,
a life-form making poem.
I'm molecules morphing
through time, DNA-shaped,
dream-blown. Life's strict
poetics, ATCG, CGTA, ignites
the mind's eye. All carbon-
capturing beetles, microbes,
old coal bogs carry life,
its long line. They carry time.

*Note: ATCG are the four nitrogenous bases—adenine,
thymine, cytosine, and guanine—that form the essential
constituents of DNA.*

## May You Be Safe

The wooden spoon redeems
the stove. The black pot
burbles black beans.
On the table, blue bowls,
walnuts, raisins, a cookbook.
For reading while cooking:
*Home Comforts*. Make
the music Miles, the wine,
merlot. Out the window,
autumn rain. Ocher leaves
twirl down. Cinnamon scents
the bread pudding. In his
kitchen chair, the black cat
Bodhisattva curls.

## Nocturne

*I just remembered the stars.*
*I love them too.*
          —Nazim Hikmet

I sit forgotten
among the foxgloves.
I chuckle pebbles
with my sandal foot.
Some rodent—rat or squirrel—
rustles, restless as yearning.
The moon, solitary queen,
dabbles in gabled windows,
in gutters. Gibbous,
gorgeous, she wanting
nothing, takes all.
I let it all go. I become
moon and stone and fern.

## Notes

**p. ix. Holy Magic:** The title and related epigraph are taken from the poem "Hieroglyphica" by Wallace Stevens. In *Stevens: Collected Poetry and Prose* (New York: The Library of America, [1954] 1997), p. 562.

**p. ix. It is not news to anyone...:** Kay WalkingStick quoted in *Kay WalkingStick: An American Artist* (Washington, D. C.: The National Museum of the American Indian, 2015), p. 77.

**p. ix. Rage for the world as it is...:** Muriel Rukeyser, "This Place in the Ways," in *Out of Silence: Selected Poems by Muriel Rukeyser* (Evanston, Illinois: TriQuarterly Books, 1992), p. 69.

**p. ix. Can you express through color your feelings about science and of life?:** Wassily Kandinsky quoted in John Gage, *Color and Culture: Practice and Meaning from Antiquity to Abstraction* (Boston: Little, Brown and Company, 1993), p. 261.

**p. 3. Color is troubled light:** Goethe's view, quoted by Mondrian in John Gage, *Color and Culture: Practice and Meaning from Antiquity to Abstraction* (Boston: Little, Brown and Company, 1993), p. 257.

**p. 6. So what good are your scribblings?:** The epigraph and quoted line are taken from "The Walls Do Not Fall" in H.D., *Trilogy* (New York: New Directions, [1944–1946], 1988), pp. 9–10.

**p. 7. Arshile Gorky (1902?–1948):** A painter who began life in Turkish Armenia, he was a victim of the "ethnic cleansing" of Armenians by Turkish troops, and with

his mother and sister experienced grueling years as a refugee. On March 20, 1919, Gorky's mother died in his arms of starvation. In 1920 he and his sister immigrated to America, where he changed his name from Vosdanik Adoian to Arshile Gorky. He became an influential painter in the New York art world. A series of tragedies—a barn fire that destroyed paintings, an auto accident, marital difficulties, and cancer—preceded his suicide on July 21, 1948. For more information see the Arshile Gorky Foundation (http://arshilegorkyfoundation.org), or the superb biography by Hayden Herrera. In this elegy, italicized words and phrases are the names of paintings. The phrase "your mother's embroidered apron" refers to one of Gorky's late abstract masterpieces, *How My Mother's Embroidered Apron Unfolds in My Life* (1944), Seattle Art Museum.

**p. 8. If you look the light of the world in the eyes...:** Derek Jarman, *Chroma* (Minneapolis: University of Minnesota Press, [1995] 2010), p. 33.

**p. 10. It is the color of fire and flame:** Alexander Theroux, *The Primary Colors* (New York: Henry Holt and Company, Inc., 1994), p. 160.

**p. 10. Trayvon Martin:** Trayvon Martin was an unarmed seventeen-year-old high-school student who, in Sanford, Florida, was shot to death on February 26, 2012, by a neighborhood-watch volunteer, George Zimmerman. Zimmerman left his car to run after Martin, who was returning from the 7-Eleven with snacks. After a wrestling match, Zimmerman shot Martin at close range. Zimmerman was acquitted on the grounds of "self defense." The killer and his family claimed that he, Zimmerman, was not a racist. But Zimmerman displays a confederate flag on his website,

in a tweet called President Obama a "baboon," has called black people "slime" and "ape," has retweeted a photo of Martin's dead body (removed by Twitter), and collaborated with a "No-Muslim" gunshop to sell confederate flags. The protests and response to the incident were national, with one result being the Black Lives Matter movement. Documentation of the case and its permutations and ramifications are voluminous. I have relied on the chronology, documents, and explanations at *Mother Jones* magazine. (http://www.motherjones.com/politics/2012/03/what-happened-trayvon-martin-explained/) accessed November 2017.

**p. 11. Love, like the heart, is red**: Derek Jarman, *Chroma* (Minneapolis: University of Minnesota Press, [1995] 2010), p. 32.

**p. 12. I see by my own light**: Sylvia Plath, "Poem for a Birthday," in *The Collected Poems of Sylvia Plath* (New York: Harper Perennial, 1960–1981), p. 132.

**p. 13. Elvis, by the way...**: Alexander Theroux, *The Secondary Colors* (New York: Henry Holt and Company, 1996), p. 34.

**p. 17. Love is a great thing...**: Henri Matisse, "Jazz" reprinted in *Matisse on Art* Revised Edition edited by Jack Flam (Berkeley: University of California Press, 1995), p. 173.

**p. 18. Pterosaurs**: Pterosaurs were not dinosaurs. They were flying reptiles with membranous wings and brightly colored crests. There were 150 or more species, the largest (the azhdarchids) being as large as a giraffe! They were fast and very light. They did not survive the Chicxulub asteroid hit (the KT event) of 66 million

years ago and have no descendants. See Mark P. Witton, *Pterosaurs* (Princeton: Princeton University Press, 2013).

**p. 21. Let us substitute/enchantment...:** H.D., "The Walls Do Not Fall," in *Trilogy* (New York: New Directions Books, [1944] 1998), p. 35.

**p. 23. Splendid Things: Grape-colored figured silk:** Sei Shonagon, *The Pillow Book* translated by Meredith McKinney (London: Penguin Books, 2006), p. 87.

**p. 25.** The reference to vowels in this poem refers to a Meret Oppenheim work titled *Quick, Quick, the Most Beautiful Vowel Is Voiding* (1934) illustrated in *Meret Oppenheim Retrospective* edited by Therese Bhattacharya-Stettler and Matthias Frehner (Bern: Hatje Cantz and Kunstmuseum Bern, 2007), p. 317.

**p. 26. The dance at the heart of being:** The quoted line in italics is from Robert Bringhurst: "What poetry knows, or what it strives to know, is the dance at the heart of being." In *Everywhere Being Is Dancing* (Berkeley: Counterpoint, 2008), p. 16.

**p. 28. The power to make:** Muriel Rukeyser, "Orpheus" in *Out of Silence: Selected Poems by Muriel Rukeyser* (Evanston, Illinois: TriQuarterly Books, 1992), p. 135.

**p. 32. I have no child...:** W. B. Yeats, "112," Introductory poem to *Responsibilities* in *W. B. Yeats: The Poems* edited by Richard J. Finneran (New York: Macmillan Publishing Company [1914] 1983), p. 101.

**p. 34. I am working out the vocabulary of my silence:** Muriel Rukeyser, "The Speed of Darkness," in *Out of*

*Silence: Selected Poems by Muriel Rukeyser* (Evanston, Illinois: TriQuarterly Books, 1992), p. 109.

**p. 35. My sister, the sun...:** Derek Walcott, "Dark August," in *Derek Walcott Collected Poems*, 1948–1984 (New York: The Noonday Press, Farrar, Straus & Giroux, 1986).

**p. 39. Let us have a good fire and be beloved:** *The Rig Veda: An Anthology* trans. Wendy Doniger O'Flaherty (London: Penguin Books, 1981), p. 100.

**p. 41. Yellowwood Wood:** The quoted line and the notion comes from "Sentinel Yellowwoods," by Allen Grossman, in *The Ether Dome and Other Poems: New and Selected, 1979-1991* (New York: New Directions Books, 1991), pp. 138–139.

**p. 45. Far below, the Skagit River...:** Robert Sund, "In the Woods above Issaquah," in *Poems from Ish River Country* (Shoemaker & Hoard, 2004), p. 107.

**p. 47. Dozens of dialectics of green:** "The Open Window," in Tomas Tranströmer, in *The Great Engine* trans. by Robin Fulton. (New York: New Directions, [1987] 2006), p. 105.

**p. 50. For the river...:** The epigraph is from "Duwamish" in Richard Hugo, *Making Certain It Goes On* (New York: W. W. Norton & Company, 1984), p. 45.

**p. 55. A blue stone...:** Richard Hugo, "Blue Stone," in *Making Certain It Goes On* (New York: W. W. Norton & Co., 1984), p. 429.

**p. 57. And so I fell in love with a color**: Maggie Nelson, *Bluets* (Seattle: Wave Books, 2009), p. 1.

**p. 63. Blue is a mysterious color...**: Alexander Theroux, *The Primary Colors* (New York: Henry Holt and Company, 1994), p. 1.

**p. 65. Requiem for Rwanda**: The epigraph is from *The Inferno* trans. by Allen Mandelbaum (New York: Alfred A. Knopf, 1995). In the thirteen weeks after April 6, 1994, some half-million people were slain in the Rwandan genocide, perhaps three quarters of the Tutsi population as well as thousands of Hutu who opposed the killings. Paris-based International Federation of Human Rights Leagues and U.S.-based Human Rights Watch released a 900-page report that documents events before and during the genocide. It criticizes the United Nations, the United States, France, and Belgium for knowing about preparations for the slaughter and taking no action to prevent it. http://www.hrw.org/reports/1999/rwanda/

**p. 66. The world is blue...**: Rebecca Solnit, "The Blue of Distance" in *A Field Guide to Getting Lost* (New York: Penguin Books, 2005), p. 29.

**p. 69. At the edge of imagination ...**: Olivia Parker, "Anima Motrix" in "Essays," OliviaParker.com.

**p. 72. Love is...**: Anne Carson, "Very Narrow," in *Plainwater* (New York: Vintage Books, 1995), p. 189.

**p. 76. ATCG CGTA**: These are the four nitrogenous bases—adenine, thymine, cytosine, and guanine—that form the essential constituents of DNA. They come in pairs and cytosine always pairs with guanine.

**p. 78. I just remembered the stars...:** Nazim Hikmet, "Things I Didn't Know I Loved," *Nazim Hikmet: Selected Poetry* trans. by Randy Blasing and Mutlu Konuk (New York: Persea Books, 1986), p. 170.

## Acknowledgments

I thank the editors of the following journals in which some of these poems appeared, sometimes in earlier versions. *River Styx, Bellatrist, Roanoke Review, Harts & Minds* (Chromatography issue), *Mudfish, The Seattle Review of Books, Grub Street Grackle, Pacifica Literary Review, Tampa Review, Sow's Ear, The Wandering Hermit Review, The Seattle Review, PoetsWest,* Terrain.org, *Cincinnati Poetry Review,* and *Visions.* Four anthologies in which poems appeared are *Take a Stand: Art Against Hate* (Seattle: Raven Chronicles, 2019–2020); *WA 129: An Anthology of Poetry from Citizens of Washington State* (Spokane: Sage Hill Press, 2017); *Pontoon: Anthology of Washington State Poets* No. 9 (Seattle: Floating Bridge Press, 2006); and *Seattle Five Plus One: Poems* (Youngstown, Ohio: Pig Iron Press, 1995).

I must thank the poet Deborah Woodard, who devoted two afternoons at Celine Patisserie up on Greenwood Avenue to helping me to cogitate and order these poems. Without the perceptive scrutiny of my dear friend Bethany Reid, fellow poet, this work would be a mess.

Geri Gale, poet and novelist, has ever been a staunch support. I am grateful for her perusal and comments on these poems and for her friendship. My friend Mitra (Bhikshu Dharmamitra) read and recognized these poems. Thank you.

I thank my old friends in Boston for keeping the home fires burning. I'm so glad that remaining here on Earth are Saul Slapikoff, Flora González, Jim O'Brien, Farah Ravenbakhsh, and Deborah Lee, as we somehow learn to live without Louis Kampf (1929–2020).

I dedicate these poems to Jane Schlosberg and Sandra
Nickerson, both visual artists, and to my late sister
Susanne. There is no way to thank enough the first
people to be actually happy that you are writing poems.
Both Jane and Sandra have created images in dialogue
with one or more of the poems, which, unfortunately,
threw all the other poems into fits of jealousy. Susanne
was the first person I ever sent a poem to. I live with
her watercolors and with vivid memories of her beauty
and her funny sense of humor. It's hard to believe she
has been gone for more than thirty years. I dedicate this
book as well to my dear mentor and therapist over many
years, Janiese Loeken. Words cannot express....

My Third Sunday workshop has its fingerprints all over
everything I write. Great thanks to Jack Remick, M. Anne
Sweet, Geri Gale, Meredith Bricken Mills, Frank Araujo,
and, in past years, Gordon Wood. Not to forget the
Tuesday/Friday writing-practice group, founded by Jack
Remick and Robert J. Ray, carried out on Zoom during
these days of the COVID-19 plague: Jerry Jaz, Melanie
Grimes, and Nancy-Lou Polk, among others. I'm grateful,
too, to Susan Knox and Andrea Lewis, my team for
sending our work out into the world. How we miss our
friend the late Waverly Fitzgerald.

I am a beneficiary of Seattle's vibrant poetry scene,
which is too massive and diverse to mention in all
its convolutions and permutations. In particular I
must thank the Jack Straw Cultural Center led by Joan
Rabinowitz; the It's About Time reading series founded
by Esther Helfgott; PoetsWest founded by J. Glenn Evans
and the late Barbara Evans; Raven Chronicles, now
managed by Phoebe Bosche; SPLAB, the brainchild of

Paul E. Nelson; the amazing LitFuse poetry conference held every year in Tieton and founded by Michael Schein; David D. Horowitz and his Rose Alley Press; our indispensable Elliott Bay Book Co.; Chris Jarmick and his BookTree; Open Books, Seattle's poetry-only bookstore; and Richard Hugo House, Seattle's vibrant center for writers. Which is merely to skim the surface.

I am proud to be part of HistoryLink.org, the free online encyclopedia of Washington state history and its ever-jolly crew.

Finally thank you to Lana Hechtman Ayers, book designer Tonya Namura, and the folks at MoonPath Press, along with Carmen Germain, judge for the Sally Albiso Poetry Book Award, for choosing these poems and presenting them so well. I am proud to follow in the footsteps of the poet Sally Albiso and thank John Albiso, Sally's husband, for establishing the award in her memory.

These poems go to my family, especially Pamela O. Long and Bob Korn, Liz Long and David Messerschmidt, and to my dear partner Jay Schlechter, with great love and with the reminder that I am owed a chocolate cake.

## About the Author

Priscilla Long is a Seattle-based poet, writer, editor, and a longtime independent teacher of writing. She writes science, poetry, history, creative nonfiction, and fiction. She is author of six books (to date), including the how-to-write manual *The Writer's Portable Mentor*. Her work appears in numerous literary publications, both print and online, and her science column "Science Frictions" ran for 92 weeks online at *The American Scholar*. She has a Master of Fine Arts degree in creative writing from the University of Washington and serves as founding and consulting editor of HistoryLink.org, the free online encyclopedia of Washington state history.

Of her writing, the novelist Laura Kalpakian said, "She won't be confined by forms. This is what made her recent *Fire and Stone* such a protean, exciting book. Yes, it's a vivid memoir, but she also asks questions of The Past, not simply her own, but the larger anthropological past. Priscilla Long is the enemy of slack thinking, the lazy, the euphemistic. She has a Renaissance mind ..."

Priscilla Long grew up on a dairy farm on the Eastern Shore of Maryland.

*[Excerpted from Bethany Reid, Long, Priscilla (b. 1943), HistoryLink.org, the free online encyclopedia of Washington State history (www.historylink.org)]*

CPSIA information can be obtained
at www.ICGtesting.com
Printed in the USA
FSHW020701040920

9 781936 657568